Dazzling Dogs
COLORING BOOK

Marjorie Sarnat

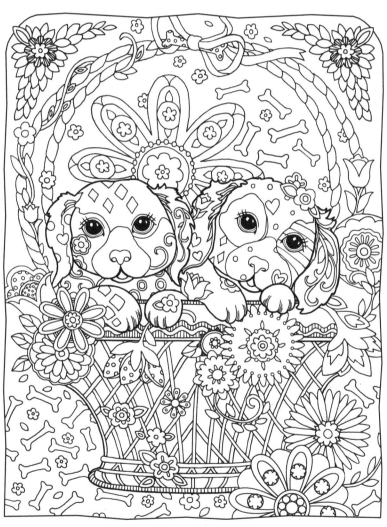

DOVER PUBLICATIONS, INC.
MINEOLA, NEW YORK

Get your colored pencils and markers ready—this delightful collection of dogs will dazzle you! The imaginative pages feature a Western-inspired guitar-wielding pooch, a space-age spaniel, an intrepid bloodhound explorer, canine chess pieces, and a pair of "hot dogs"—among many others. The intricate designs include flowers, butterflies, hearts, mechanical toys, and even dinosaurs and Native American emblems. The unbacked pages allow you to use any coloring media you like, and the perforated pages make displaying your finished work easy.

Bibliographical Note
Dazzling Dogs Coloring Book is a new work, first published
by Dover Publications, Inc., in 2016.

International Standard Book Number
ISBN-13: 978-0-486-80382-1
ISBN-10: 0-486-80382-1

Manufactured in the United States by RR Donnelley
80382101 2016
www.doverpublications.com

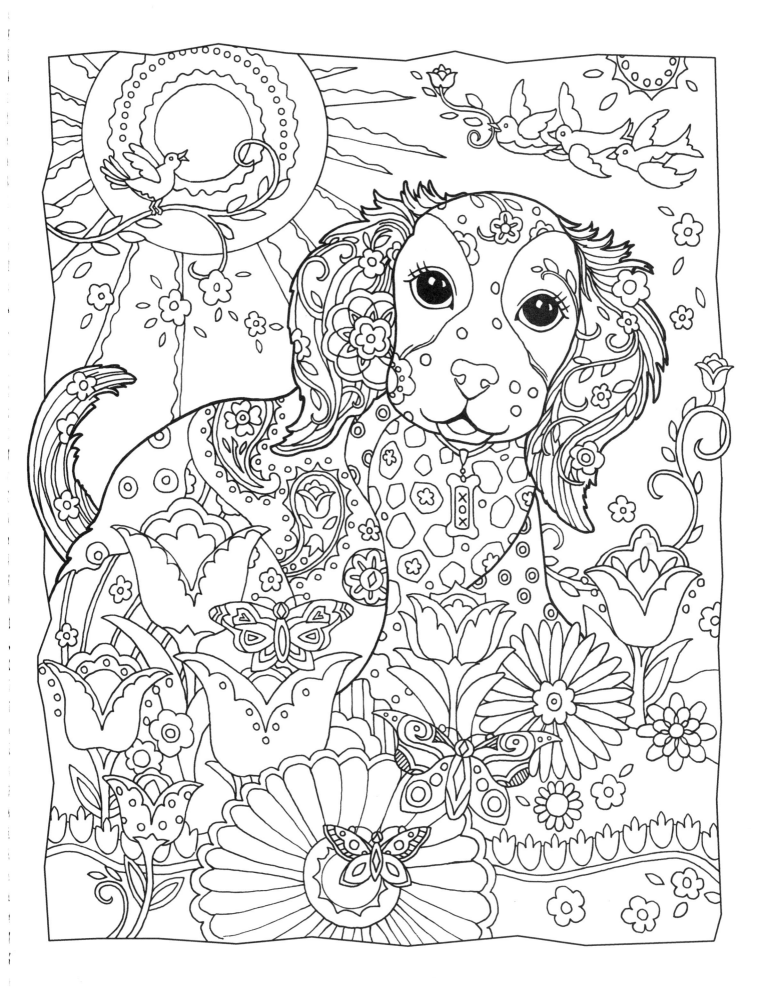

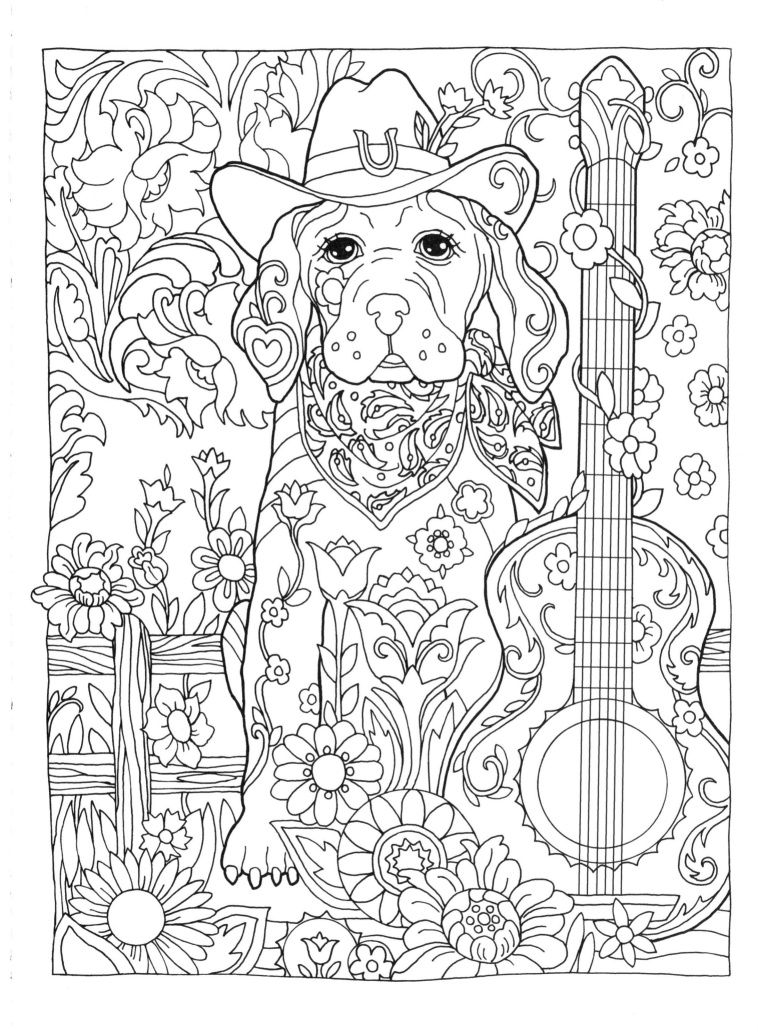

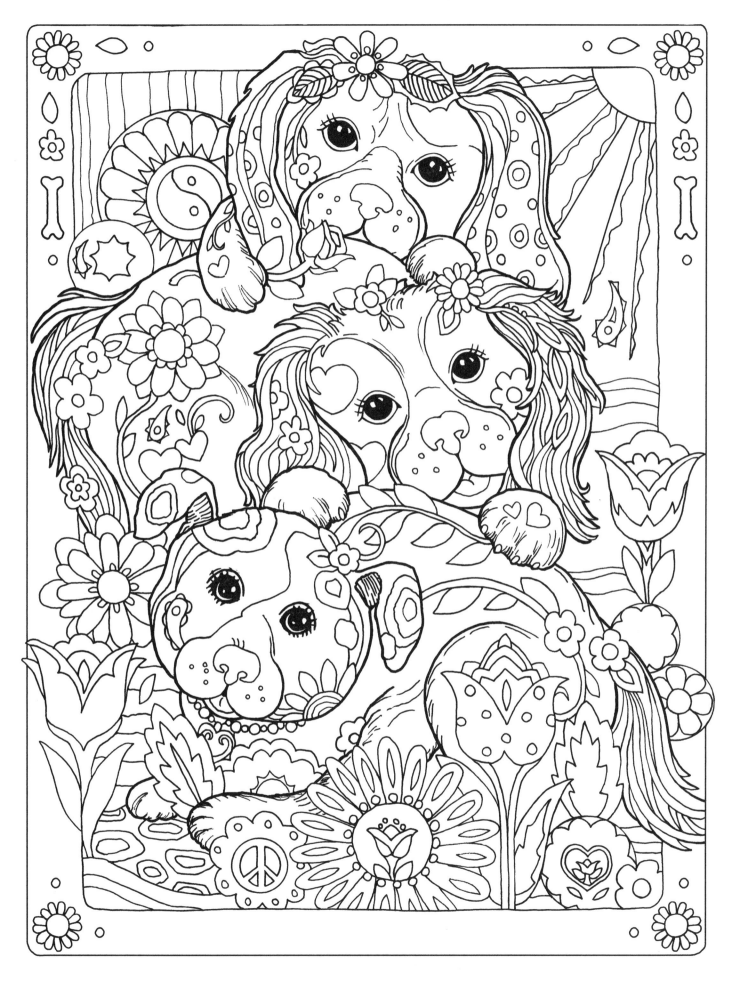

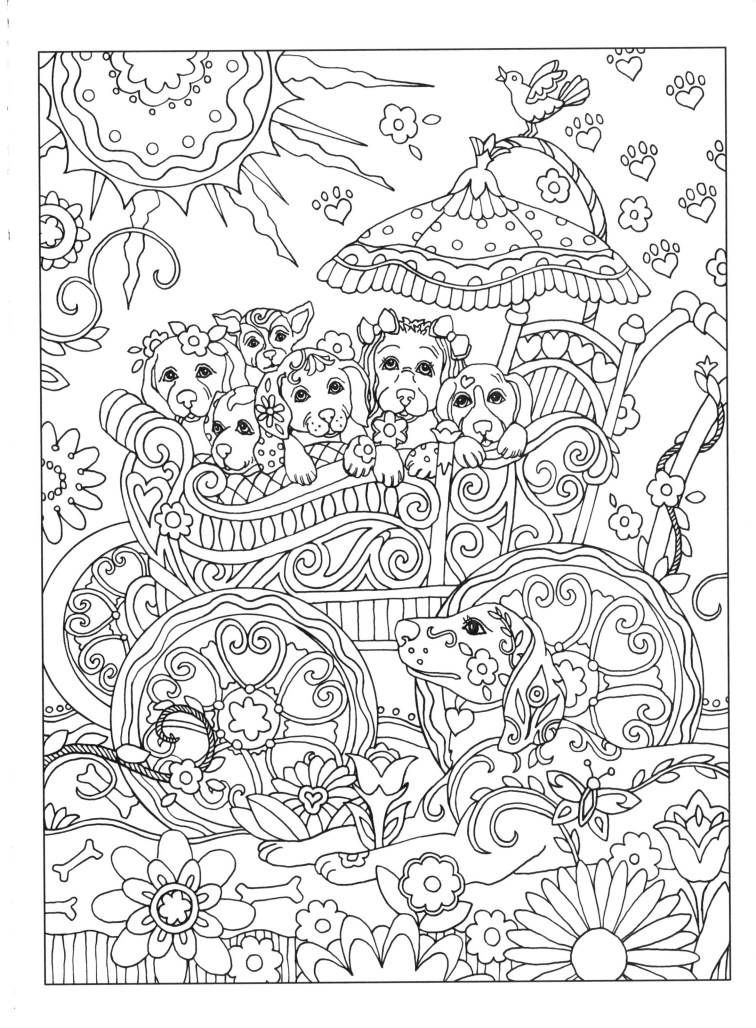

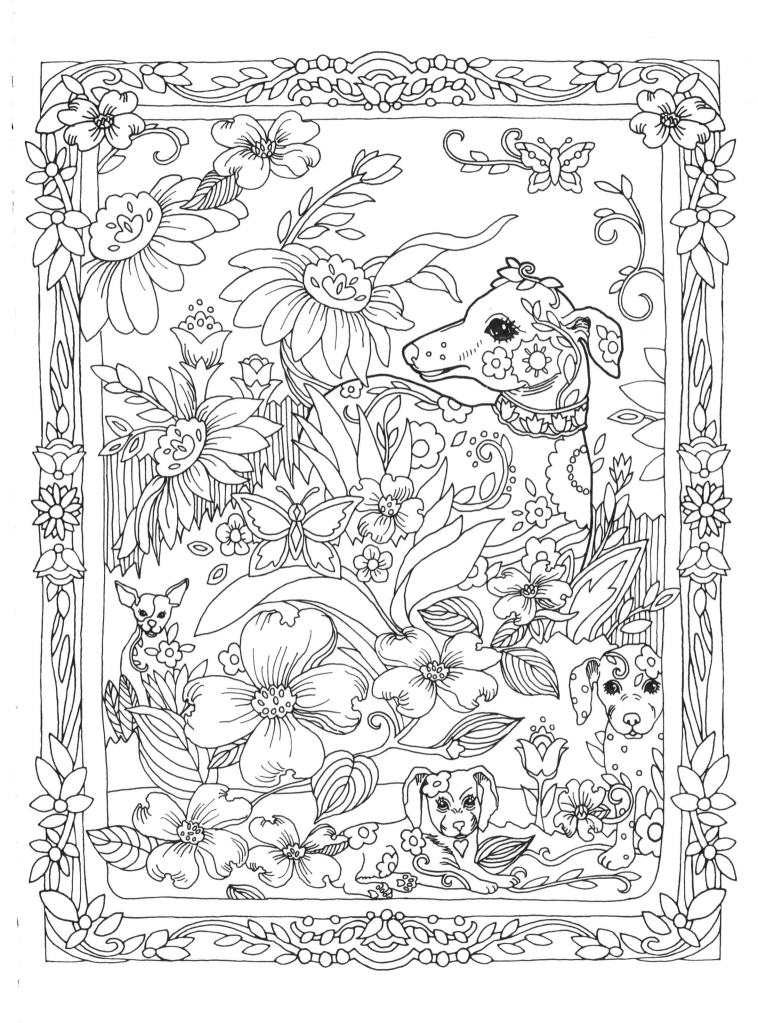

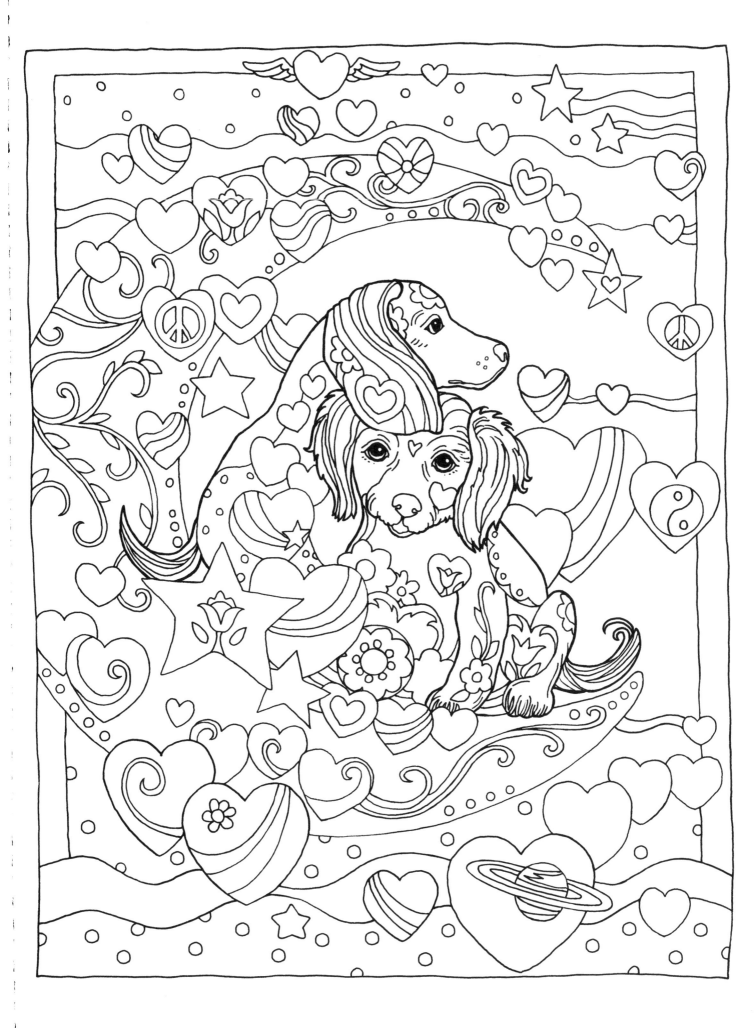

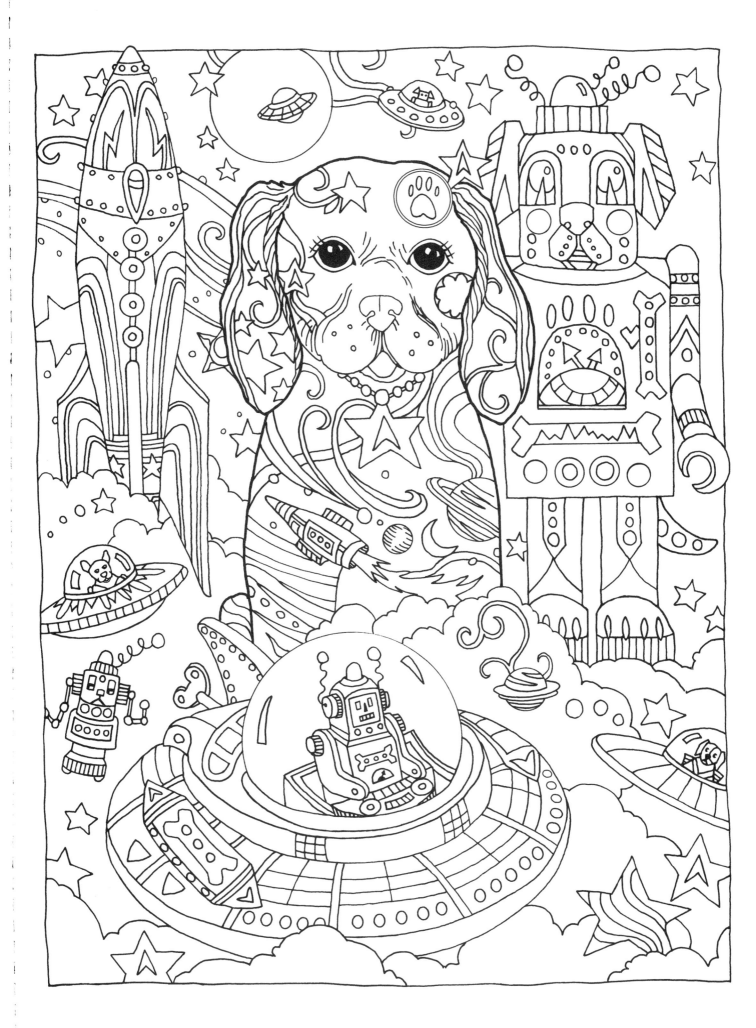

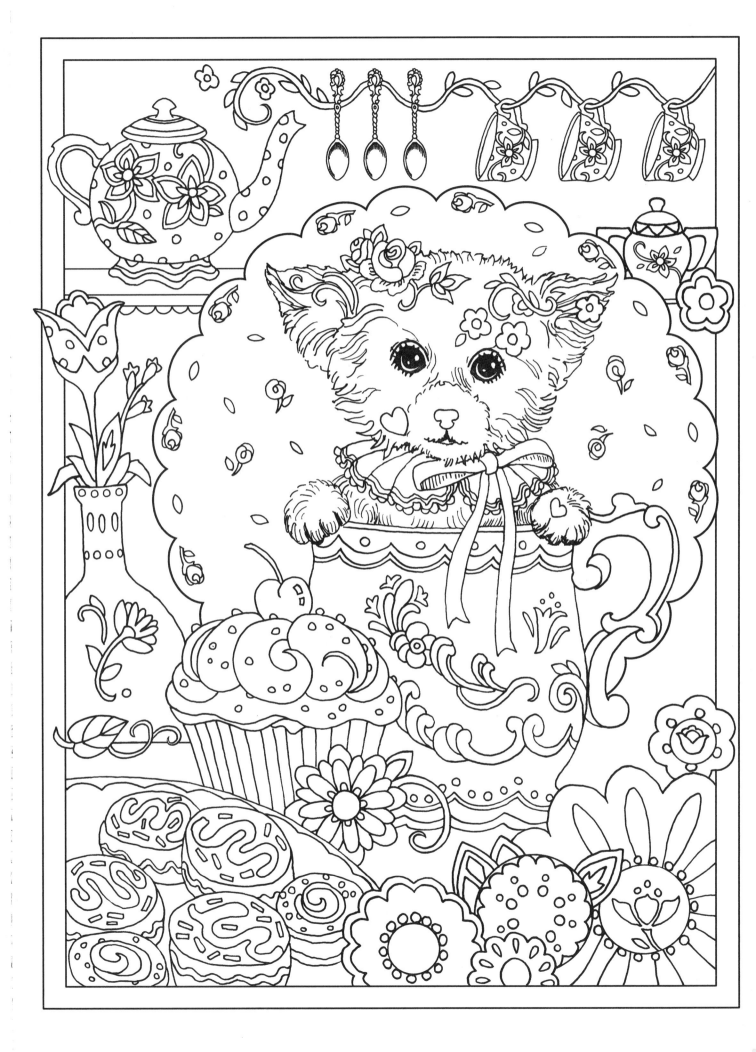

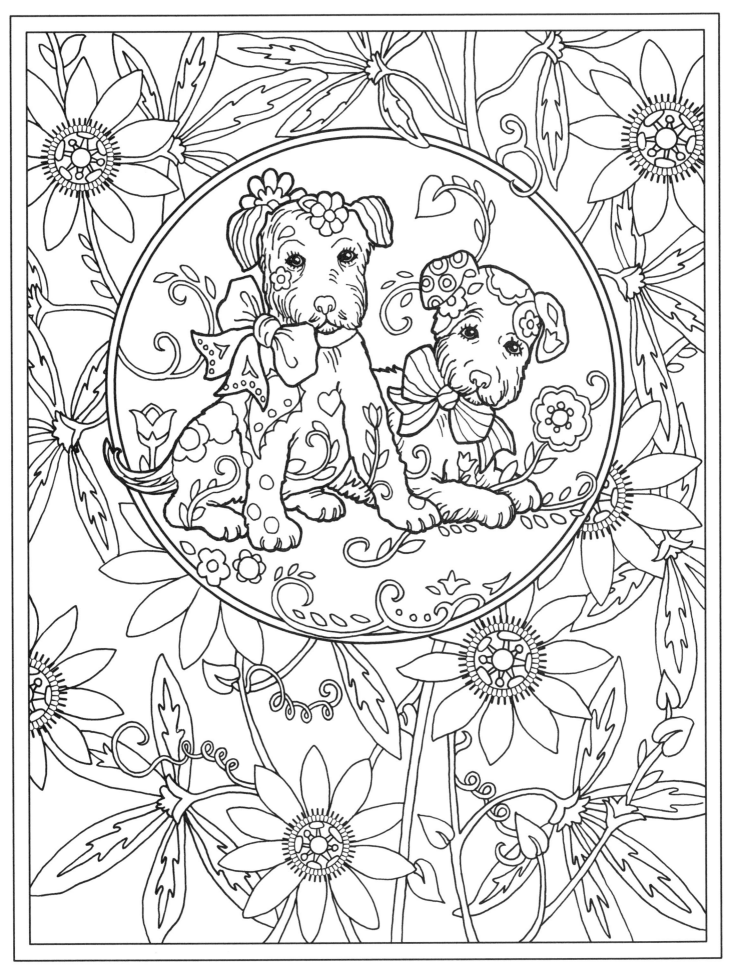

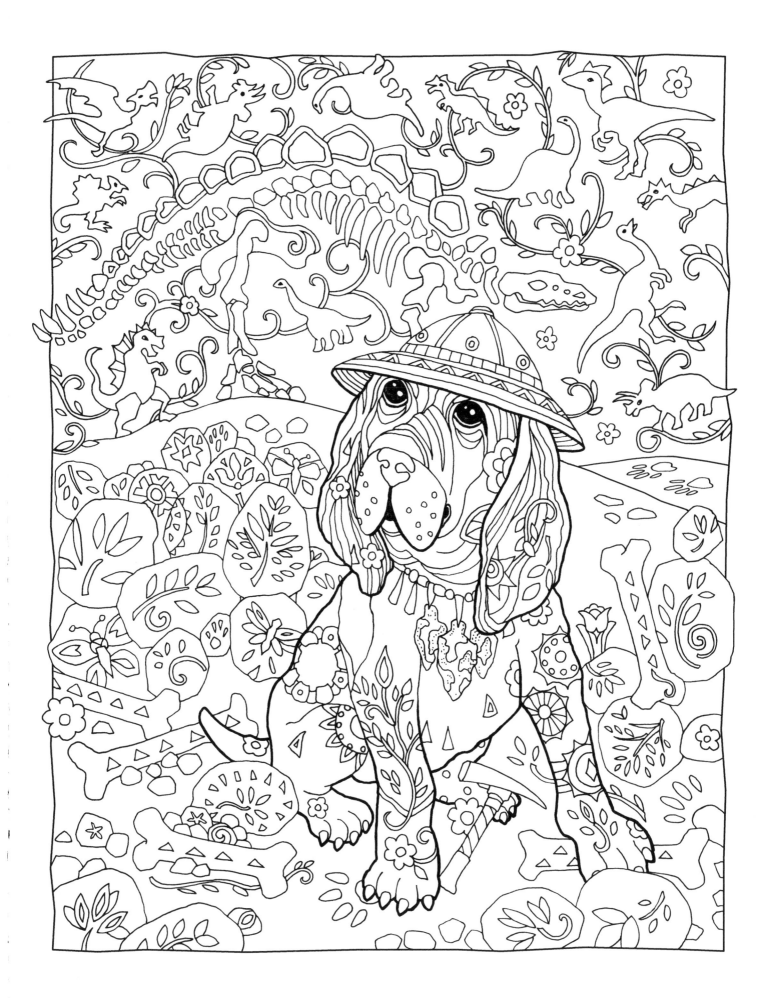

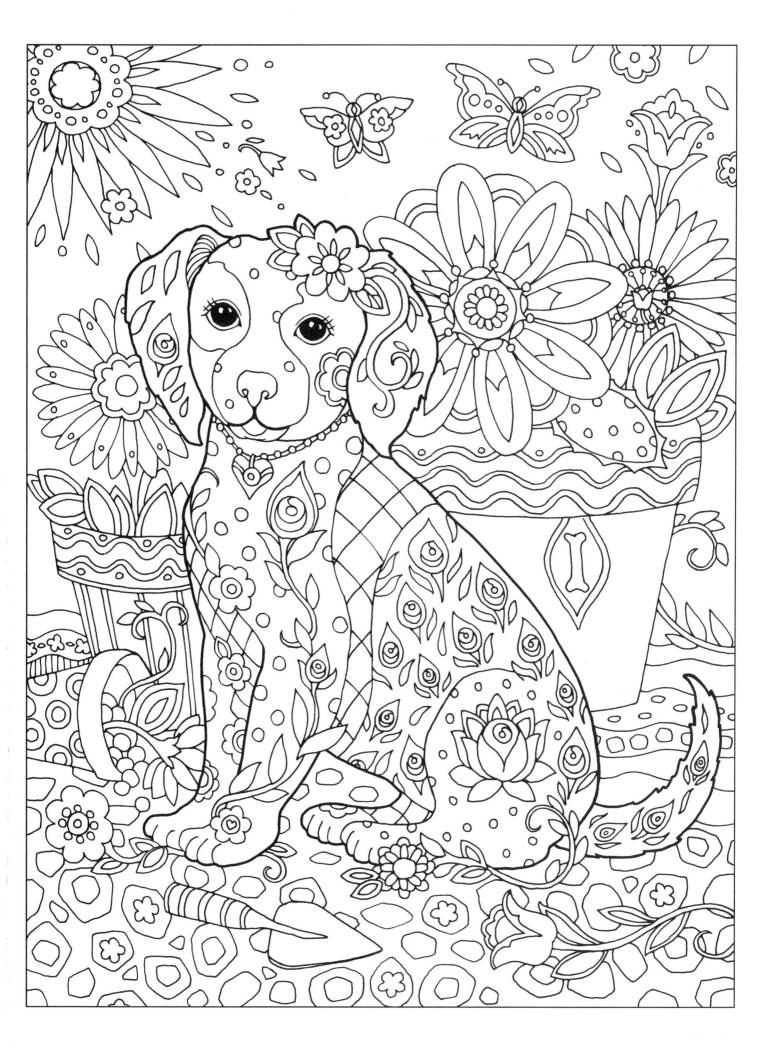

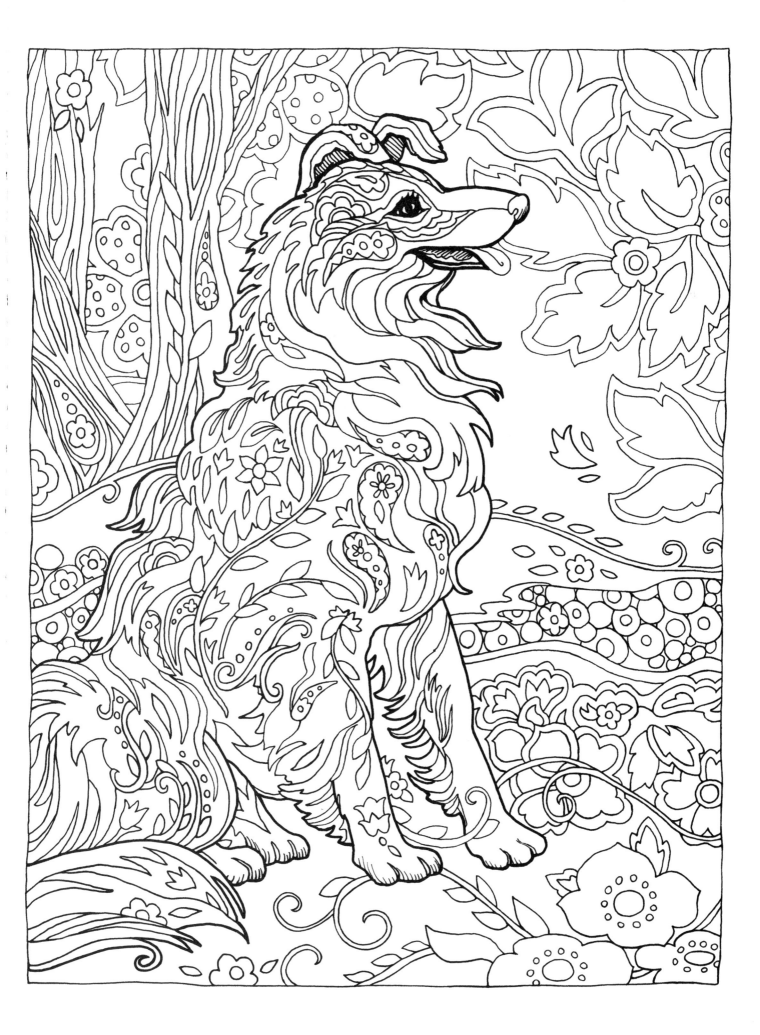

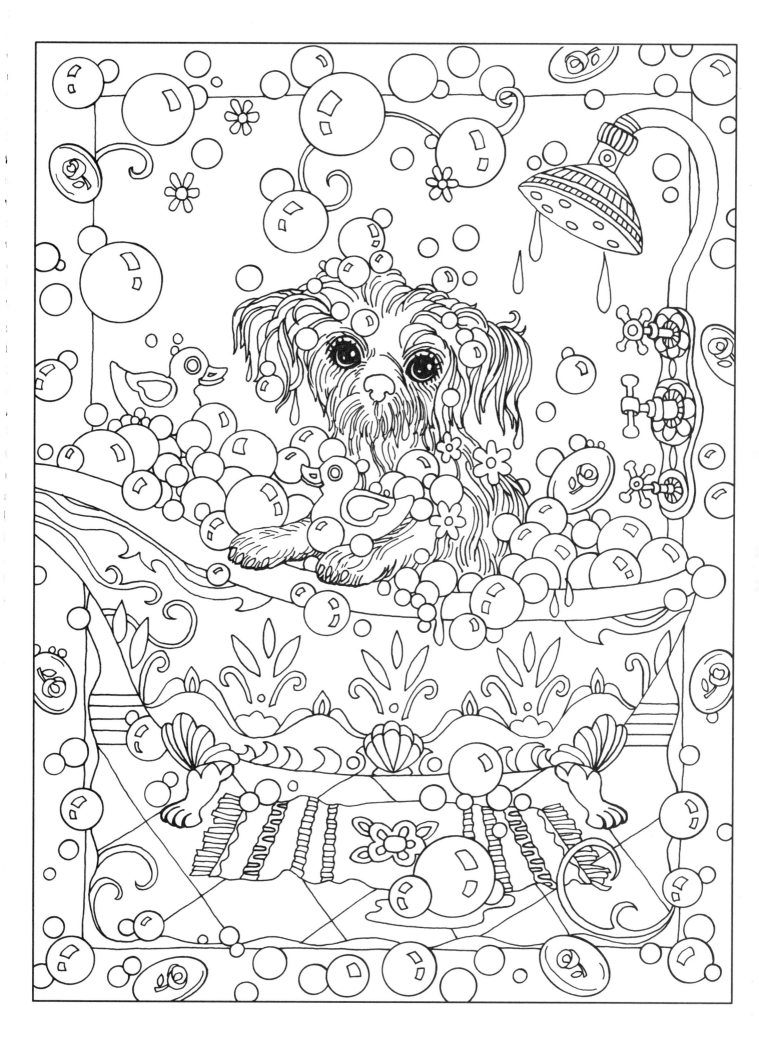

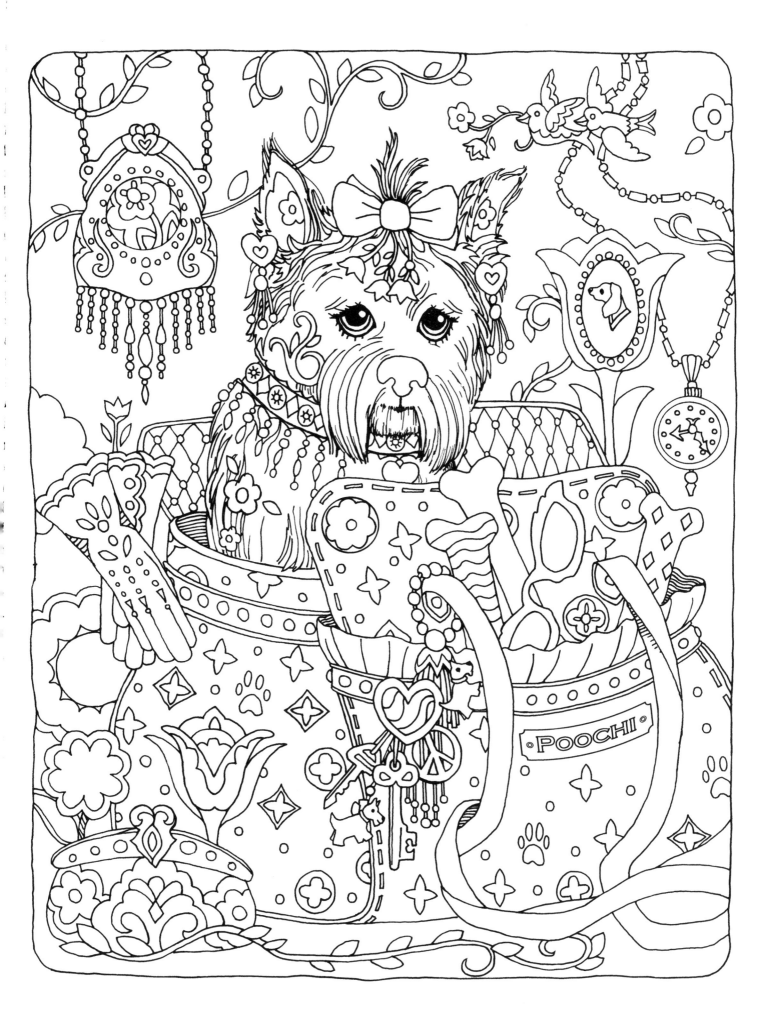

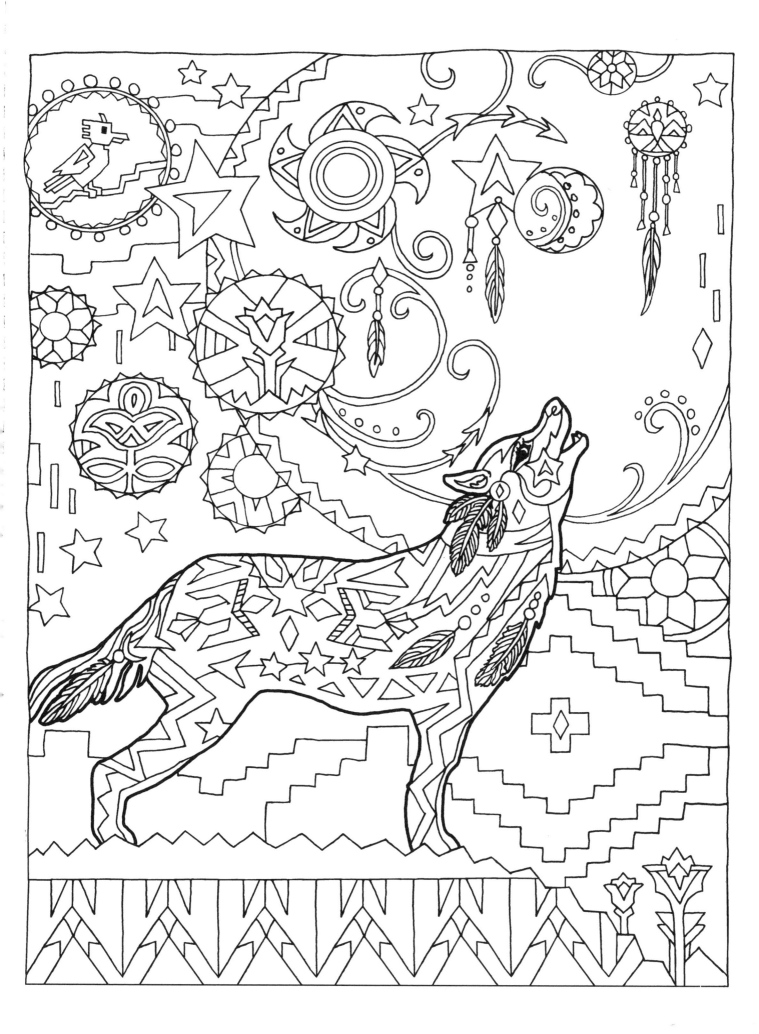

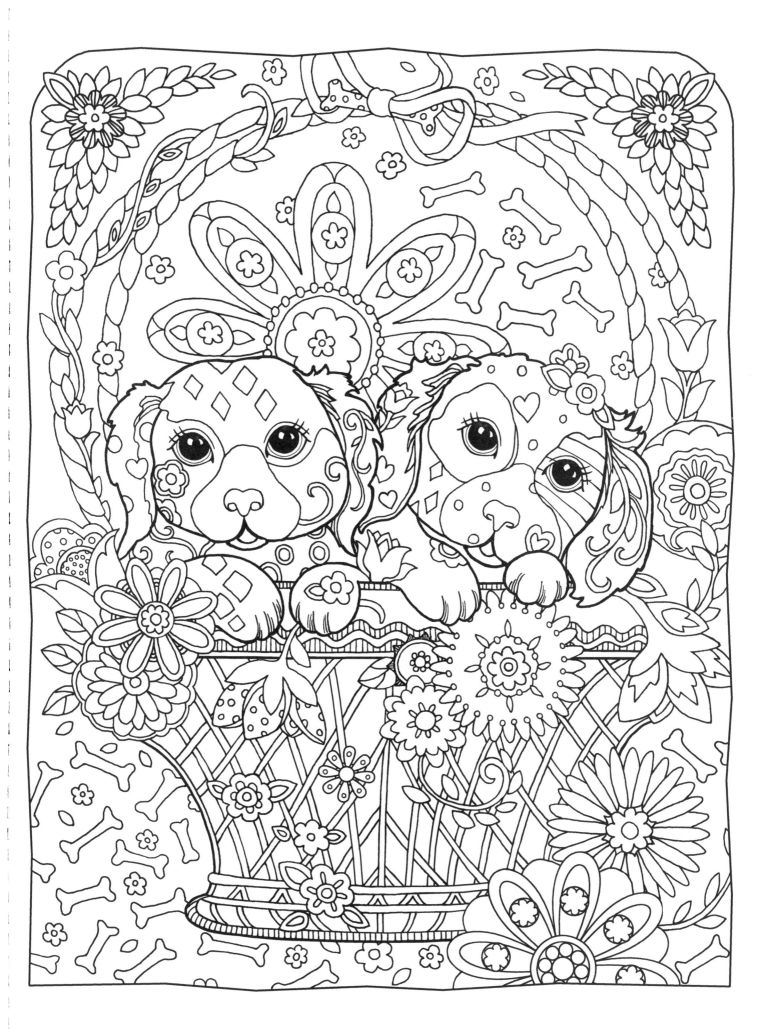

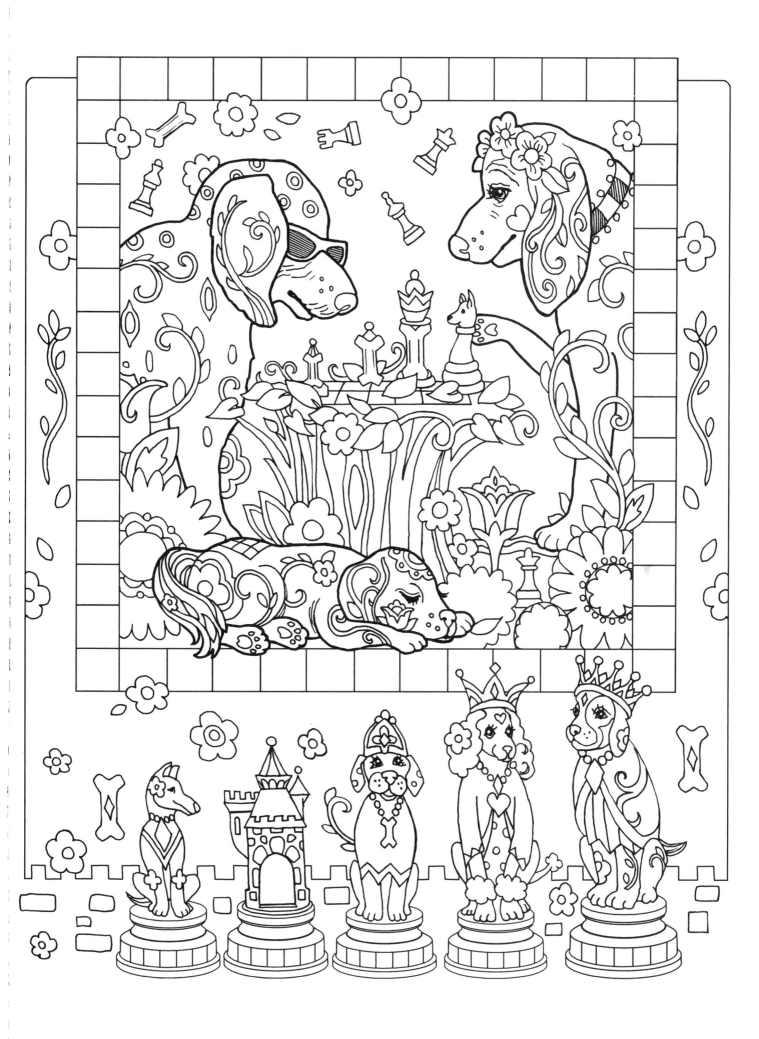

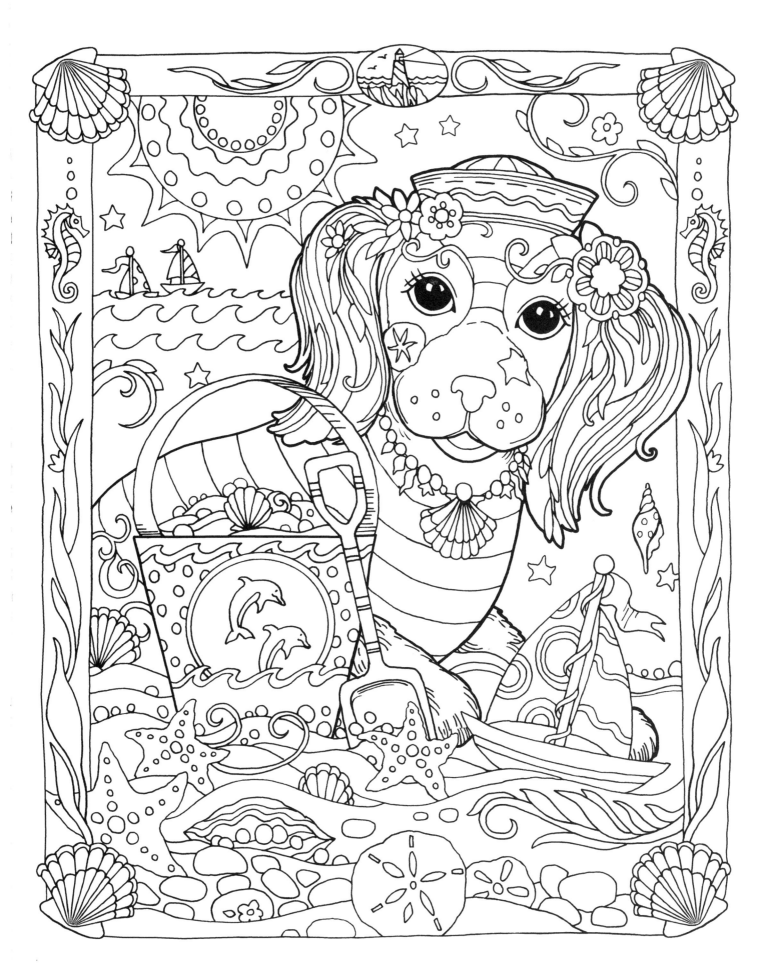

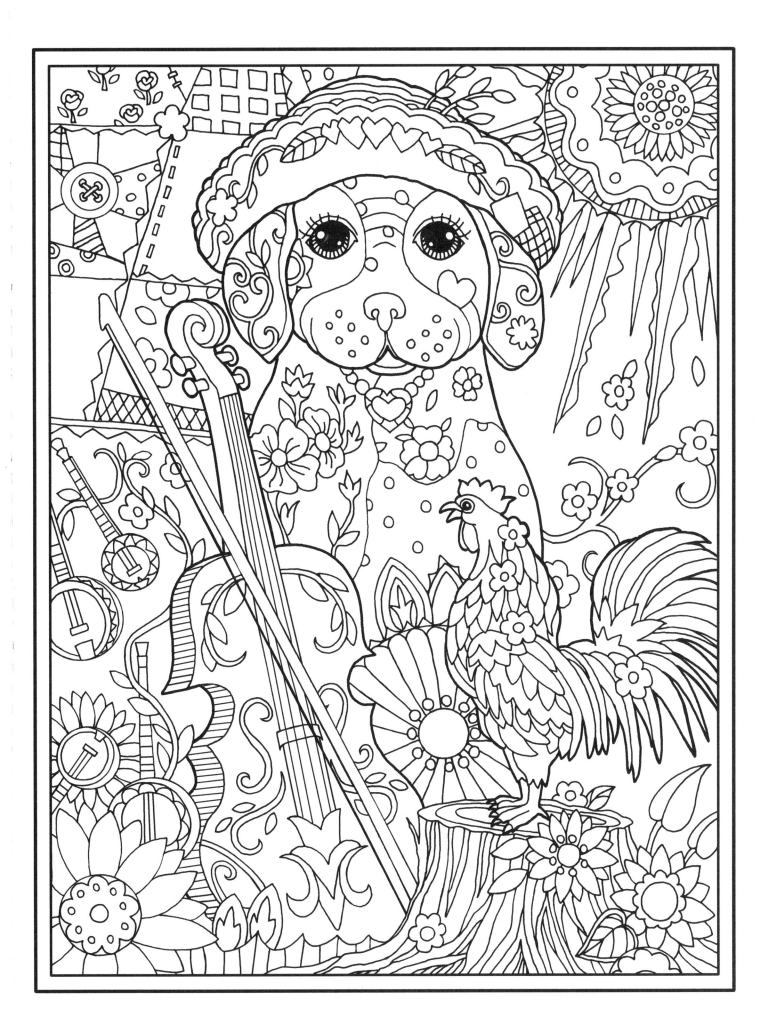

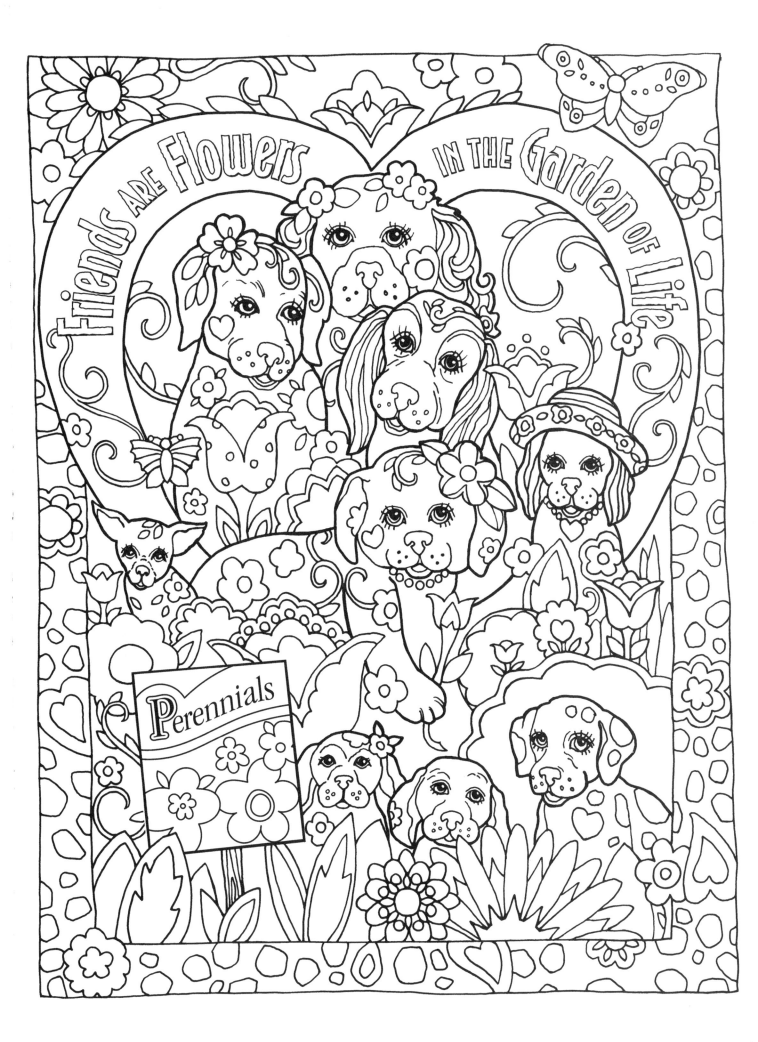

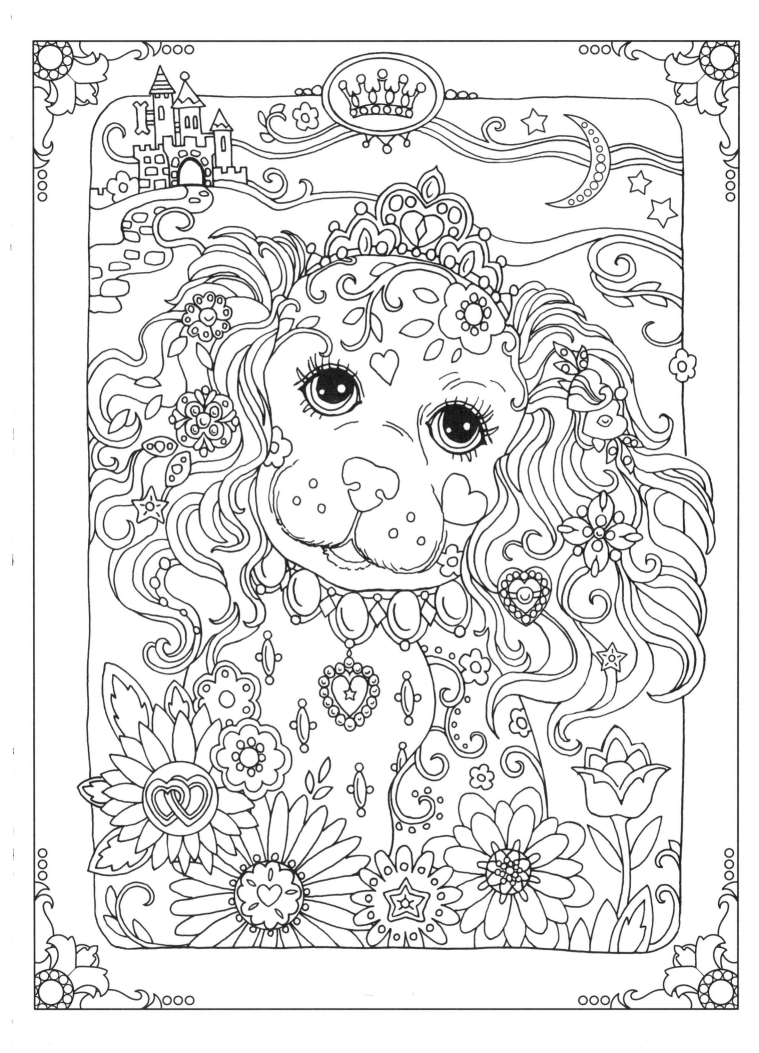

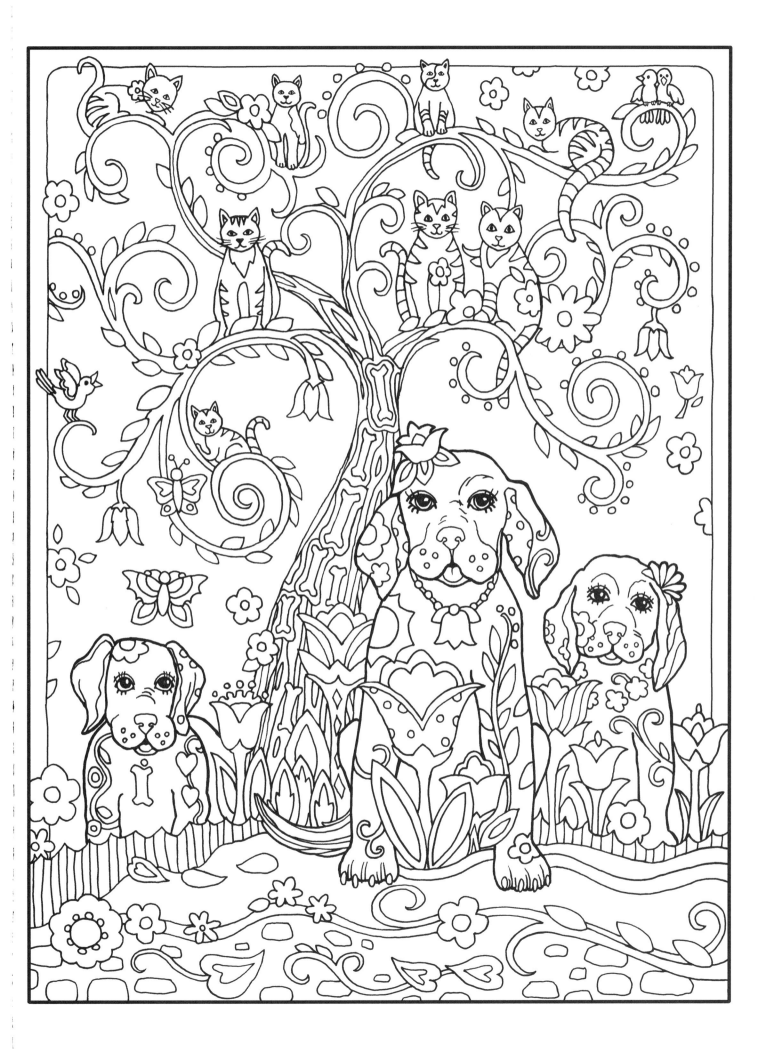

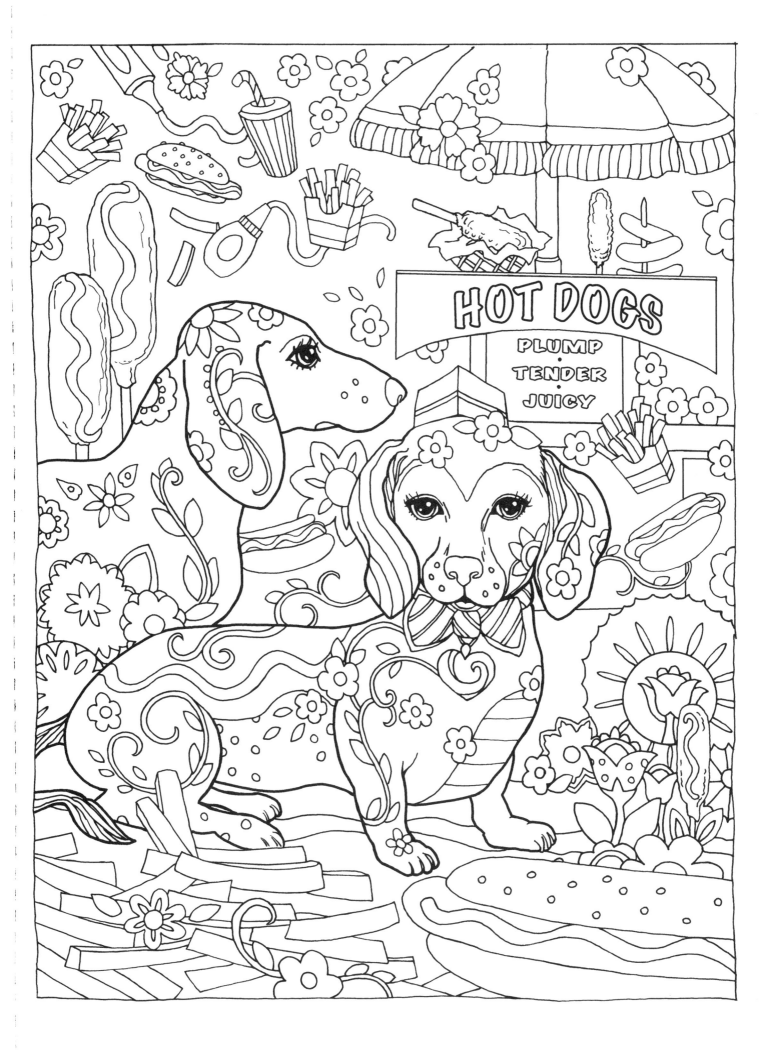

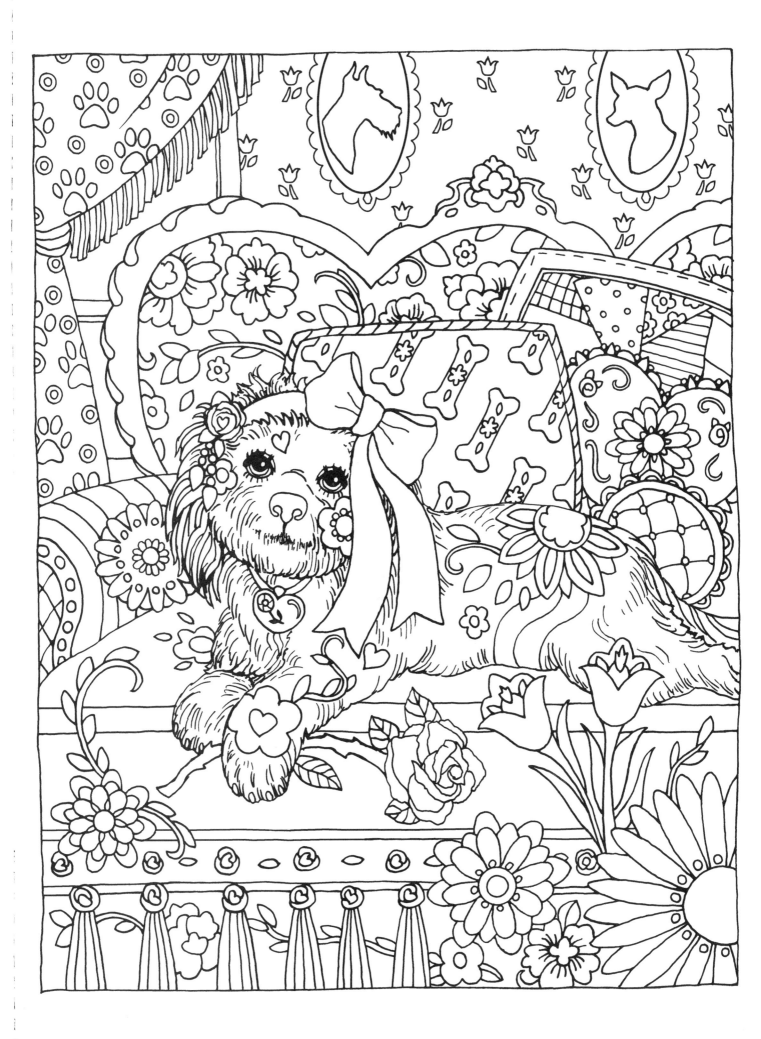

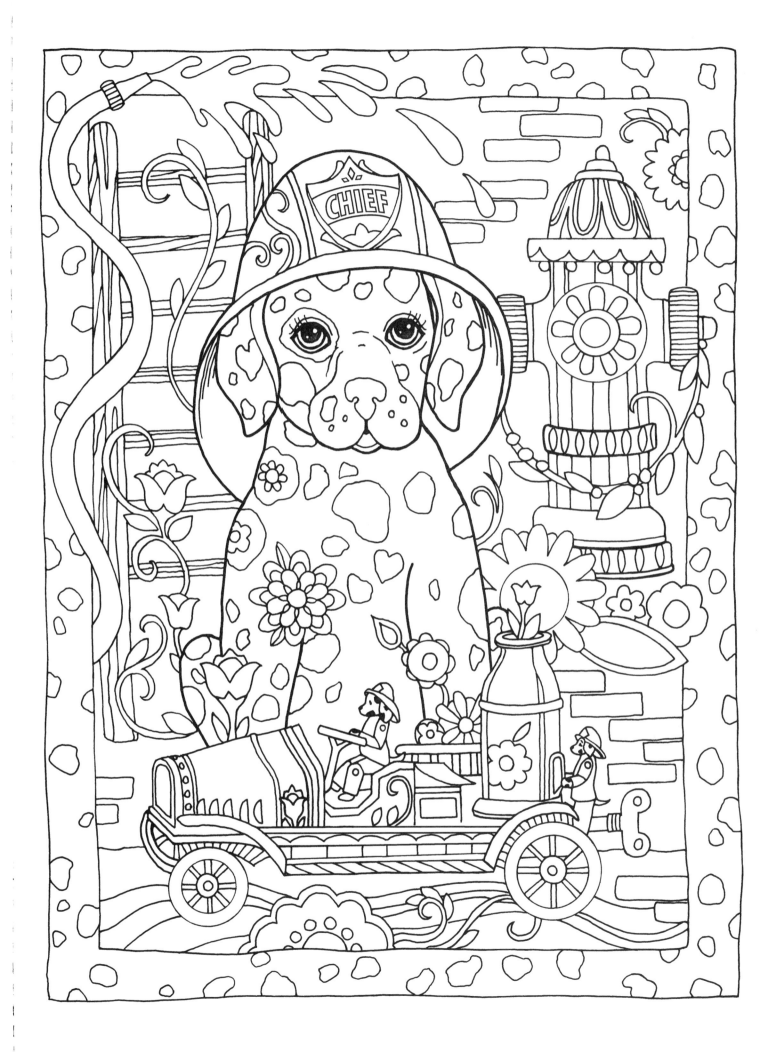

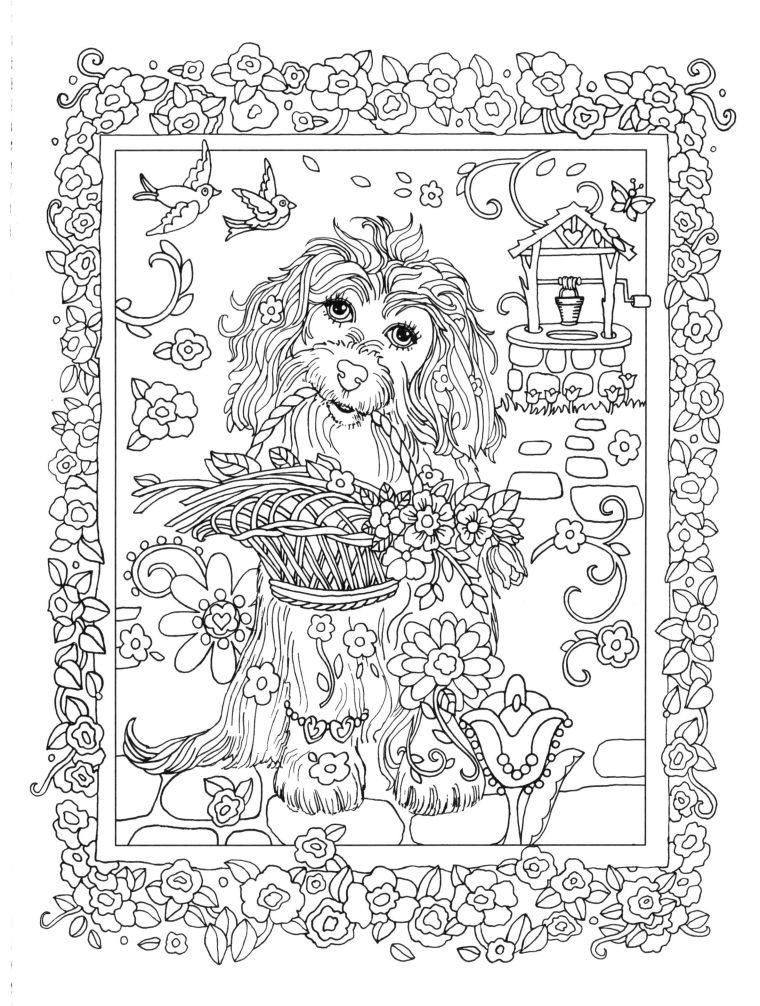

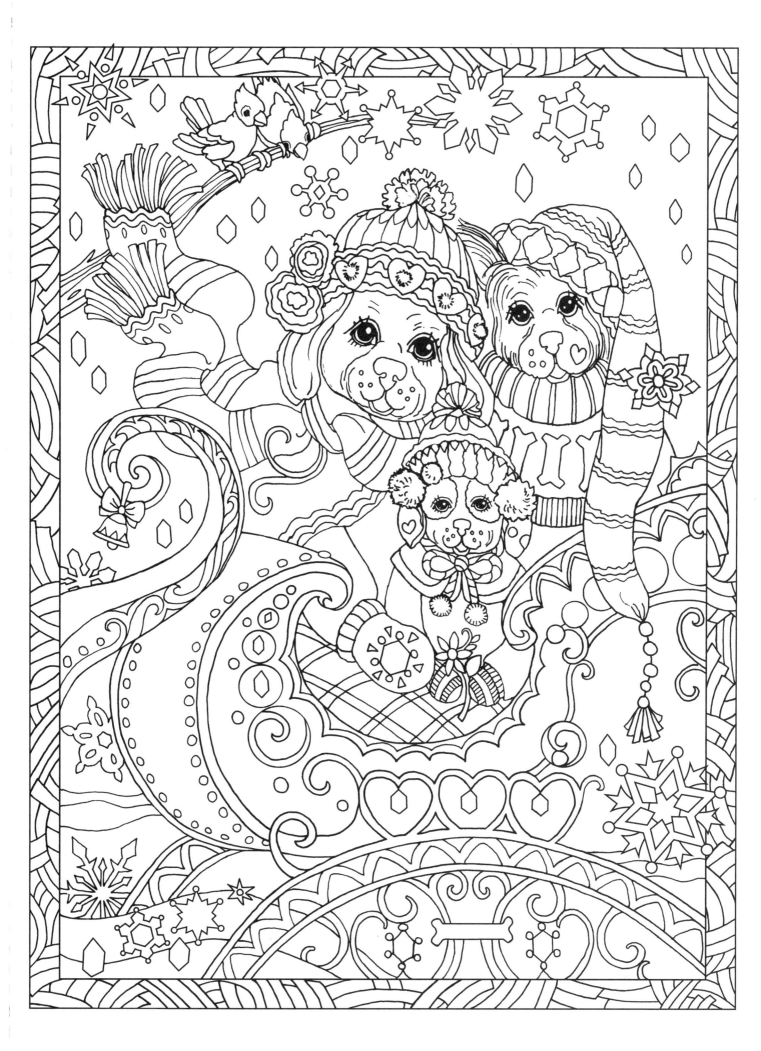

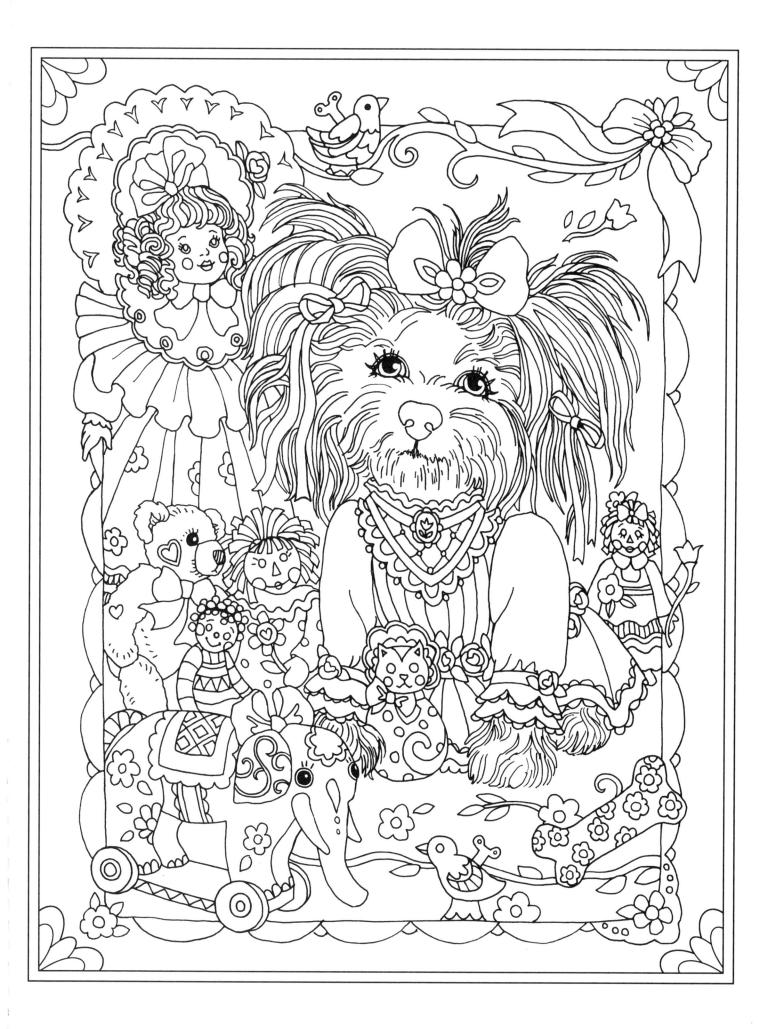

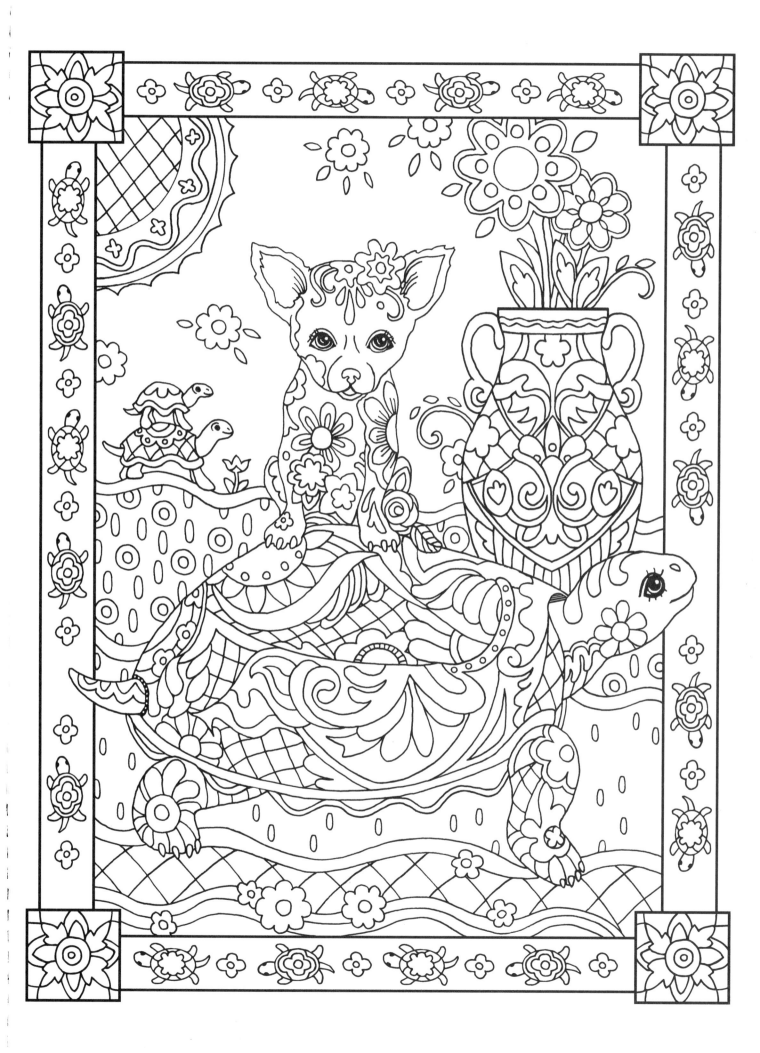

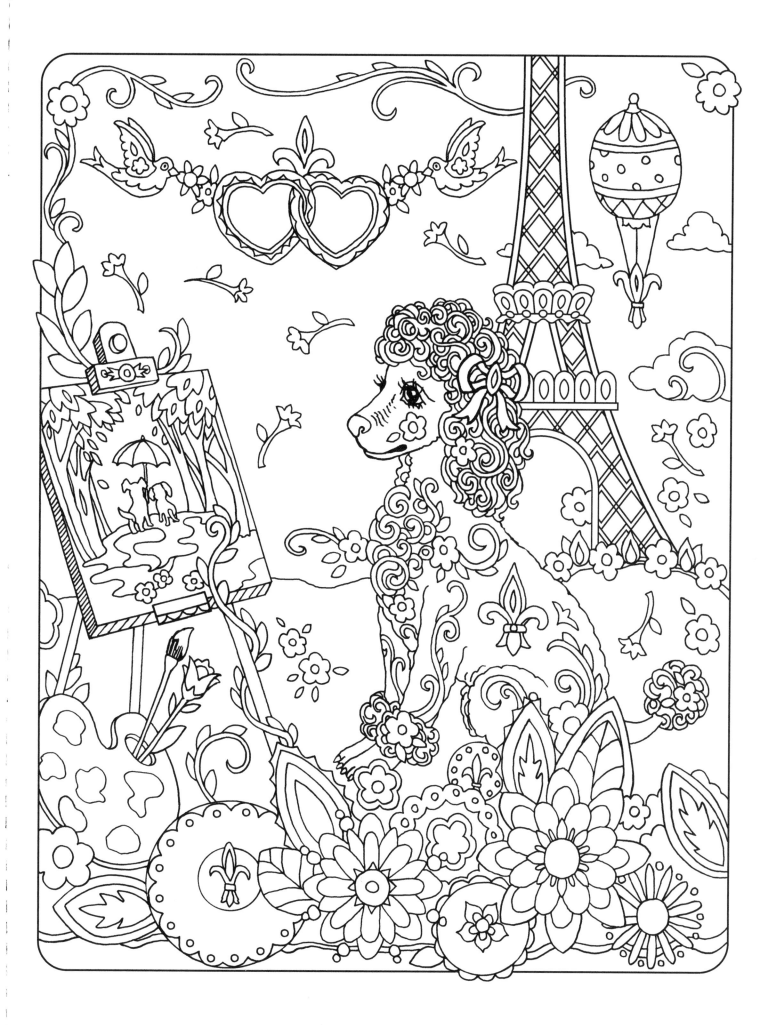

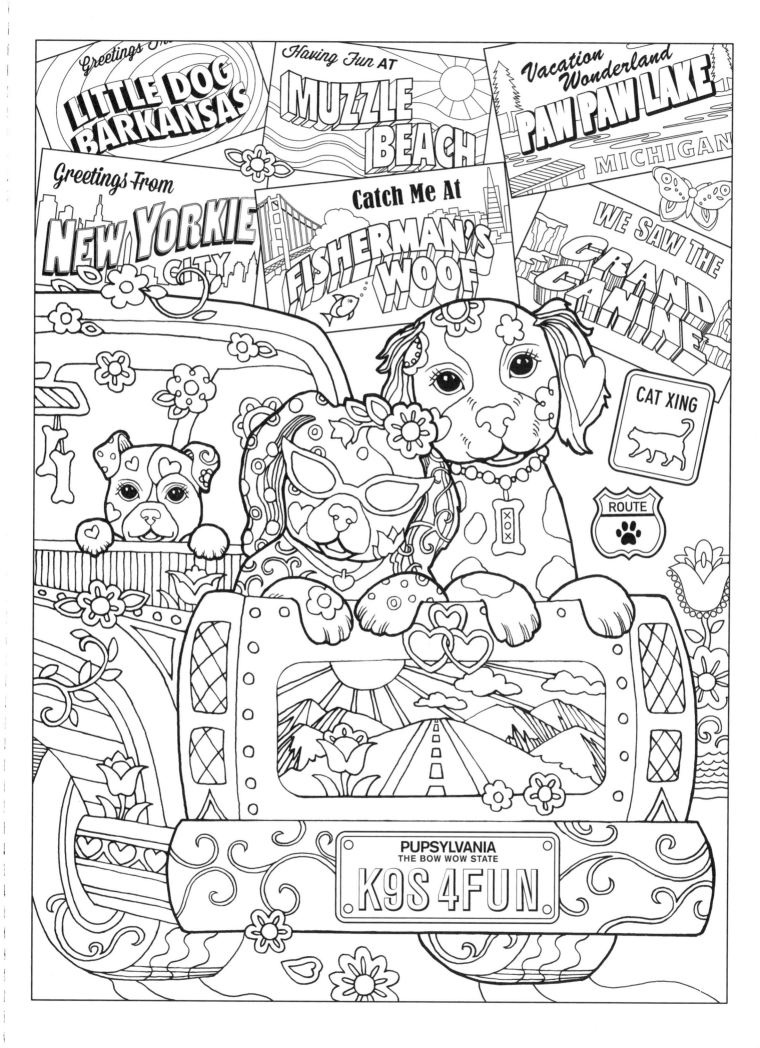